Garnitures

VASE SETS FROM NATIONAL TRUST HOUSES

V&A PUBLISHING

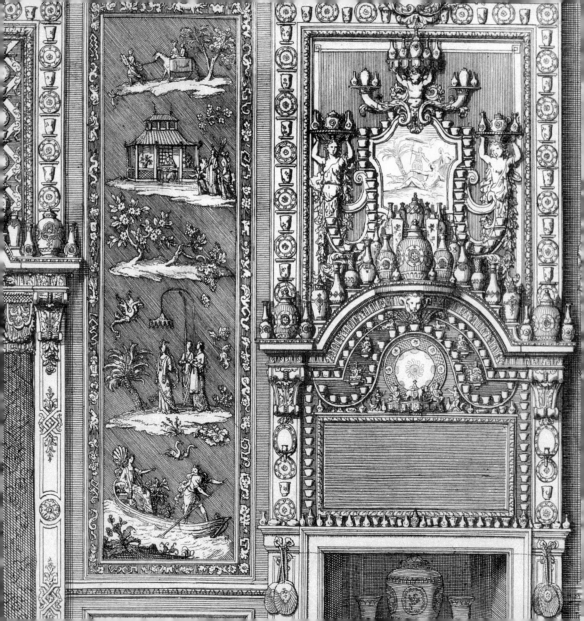

Introduction

The familiar practice of displaying a vase prominently, on a mantelpiece or table, seems to us a most obvious and natural thing to do. Ornamental vessels appeared in Renaissance Florence, where the wealthy elite displayed imported ceramics – dishes, storage jars and ewers – in Spanish lustrewares (ceramics with an iridescent metallic glaze) in their most private rooms. During festive banquets, these were also displayed on elaborate, tiered sideboards as a worthy alternative to precious metalware.

However, the ornamental vase only begins to make regular appearances in Western domestic interiors from the early seventeenth century onwards, as an import from China, where it was associated with the display of flowers. In Europe, the earliest ornamental vessels in Chinese porcelain, which included jars, bowls and beaker-shaped vases, were often displayed in groups. These early 'sets', assembled from vessels unified by their painted decoration in blue, were symmetrically arranged on top of furniture. They also decorated or garnished the chimney, and came to be known in France as *garnitures de cheminée*, or 'chimney ornaments'. This publication explores how matching vase sets have been used in Europe to embellish or 'garnish' interiors.

With the foundation of the Dutch East India Company in 1602, the Dutch replaced Portuguese traders as the chief importers of Chinese porcelain. Until the mid-1640s, hundreds of thousands of porcelain objects, including jars, beakers and other vessels, reached Holland annually from China. Some of these were in unfamiliar shapes and had no obvious function. Paintings of Dutch interiors (see p.21) often include groupings of three or more Chinese vases, bowls and dishes symmetrically placed on top of cupboards, or on high cornices above the fireplace

and doorway, or on panelling around the room. These 'sets' were assembled from pairs and single pieces with more or less similar decoration. Their rounded shapes and shiny surfaces, in pure white and vibrant blue, added brilliant accents to the predominantly dark interiors, where they could be admired as a display of wealth, luxury and sophistication. Some of the finest pieces entered the collections of the European courts, where whole cabinets dedicated to their display (known as porcelain rooms, see p.2) developed during the second half of the century. In contrast, more modest assembled sets of three, five, seven or nine pieces soon spread throughout fashionable Europe.

When Chinese exports were temporarily interrupted, beginning in 1644, European merchants ordered Chinese-style jars and beakers from Japan. Potters in Delft, meanwhile, also rose to the challenge and produced their own successful alternatives in tin-glazed earthenware with matching decoration. In Britain, sets of bowls and vases for the interior were made in chased silver; several rare examples are included in this publication (pp.26–31). When the trade in Chinese porcelain resumed in the 1680s, sets of matching vases were produced for a growing European market. Once the secret of porcelain was finally mastered in Europe, in the early eighteenth century, many local factories produced their own versions of garnitures with matched decoration.

Today, complete garnitures of matched vases are rare, and even fewer survive in their original settings. The collection of garnitures held by the National Trust for Places of Historic Interest or Natural Beauty is unrivalled anywhere in the world; few institutions could present a similar history of the vase set. The contents of many of the

National Trust's (NT) historic houses can be traced in the family archives of their past owners, providing evidence of when they were acquired or displayed. The Victoria and Albert Museum (V&A), London, is grateful to the NT for their collaboration on this project and for lending such important objects from 13 different houses for the display *Garnitures: Vase Sets from National Trust Houses*. For the first time in their histories, these garnitures have been temporarily removed from their historic settings, in order to present an overview of this much overlooked ceramic phenomenon.

Our special thanks go to the staff of the NT: David Adshead, Helen Fawbert, Emma Gilliland, Helen Lloyd, Andrew Loukes, Susan Paisley, James Rothwell, Christopher Rowell, Selma Schwartz, Janet Sinclair, Emma Slocombe and Fernanda Torrente; to the photographers Richard Davis (V&A), Mike Fear, Chris Lacey and Robert Morris; to conservators Zoe Firebrace, Ros Hodges, Fiona Jordan and Bouke de Vries; and to staff of the V&A, including Nickos Gogolos, Alun Graves, Dawn Hoskin, Yu-Ping Luk, Sara Mittica, Frances Parton and Heike Zech. We would also like to thank Lord Egremont and a private collection at Knole for graciously lending objects to the display. For this publication, we are indebted to Zara Anvari, Jena Fleiner, Faye Robson and Tom Windross, and to Joe Ewart, for his elegant design. Patricia F. Ferguson deserves special thanks for curating the exhibition and for writing this publication. Finally, I would like to thank Sir Timothy Sainsbury and The Headley Trust for their generous support, without which this exhibition and publication would not have been possible.

Reino Liefkes, Senior Curator, Sculpture, Metalwork, Ceramics and Glass, V&A

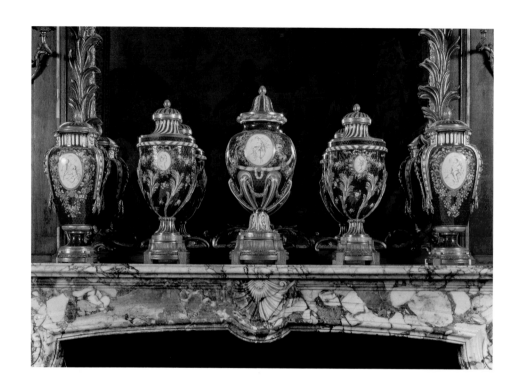

Five-piece Sèvres garniture, 1769
Soft-paste porcelain with polychrome enamels and gilding;
gilt bronze
Height: 45.2 cm
Sèvres, France
National Trust, Waddesdon Manor, Buckinghamshire
(bequest of James de Rothschild, 1957)

The Grammar of Garnitures:
A Short History of Ceramic Vase Sets

In the West, almost every ornamental ceramic vase, from the second half of the seventeenth through to the early nineteenth century, was conceived as part of a 'garniture' – a set of vases unified by their design and specific context. Between 1690 and 1780, the majority of these garnitures were five-piece sets with matching patterns, comprising three covered jars and two cylindrical beakers – both Chinese porcelain shapes emerging in the late Ming period, between 1600 and 1644. Garnitures were displayed over chimney mantels, on the tops of cabinets, on cornices, over doors and even on the hearth inside fireplaces. Yet, despite their close association with the history of the interior, global trade and social distinction, almost nothing is known about the origin and development of this ceramic phenomenon.[1]

A rich resource for study is the unrivalled collection of ceramic garnitures belonging to the National Trust (NT), which is displayed within historic domestic interiors in over 200 houses throughout England, Wales and Northern Ireland. This publication is a record of some of these vase sets, often identified as *garnitures de cheminée* (chimney ornaments), as well as examples from two other private collections that are on loan to the NT and from the Victoria and Albert Museum (V&A), London. It charts a narrative for these transnational garnitures from a British perspective.

The French term *garniture de cheminée* has been applied to ceramics since March 1683, when, in the Parisian gazette *Mercure galant*, in a report on a French court masquerade, the nobility were described as being dressed as vessels from a seven-piece porcelain garniture. The masquerade, celebrating the end of Mardi Gras,

was organized by the courtier Gabrielle de Rochechouart de Mortemart, marquise de Thianges, the older sister of the marquise de Montespan, the official mistress of Louis XIV.[2] The Chinese porcelain forms represented included an *urne* (jar), several *rouleaux* (beakers) and figures – probably white wares representing Chinese deities. The previous year, a nine-piece ceramic assemblage above a fireplace at the Palace of Versailles had been described in the same gazette as 'A large jar for pot-pourri, four large vases and four smaller, along the edge of the mantelpiece [all translations the author's]', but the term *garniture de cheminée* was reserved for a set of silver-mounted fireplace tools, evidence of the money lavished on the fireplace during this period.[3] In the 1689 inventory of Chinese porcelain owned by the Grand Dauphin, son of Louis XIV, at Versailles, the term was used to describe over 100 vessels arranged above a bedroom fireplace on giltwood brackets and, in the 1694 edition of the *Dictionnaire de l'Académie française*, it was defined by the following example: 'there is above the mantelpiece a beautiful garniture of porcelain.'[4]

Evidently, in France, by the 1680s, symmetrical displays of Chinese porcelain unified by a probable palette of complementary blue-painted designs, whether of serial (seven or nine pieces) or massed arrangements, were a well-established fashion in the homes of the aristocracy and commercial elite. The extraordinary massed displays – placed on brackets and shelves, with mirrors behind – such as those created by Mary II in her palaces in the Netherlands and England, are best known from the engravings of the French designer Daniel Marot, published from 1703 (see pp.2, 37). Less studied are the serial displays shown in an earlier suite of French fashion prints by Nicolas Bazin, after paintings by Jean Dieu de Saint-Jean,

recording a day in the life of a *femme de qualité* (gentlewoman) (overleaf and p.35).[5] The intimate scenes apparently evoke the lifestyle and taste of Françoise Athénaïs de Rochechouart de Mortemart, marquise de Montespan. Here, five-, seven- and nine-piece garnitures, displayed above chimneys and cabinets, are repeated on cornices over doors in the same room, mirroring perhaps the serried ranks of French garden pots in faience (tin-glazed earthenware) that ornamented the gardens at Versailles in the 1660s.[6] Similar serial garniture arrangements are recorded in England at Drayton House, Northamptonshire, before 1710; Petworth House, West Sussex (see pp.40–1); and in the mid-eighteenth-century paintings of Arthur Devis.[7]

Significantly, the French formulaic groupings included a large, footed jar at the centre, flanked by several pairs of bottle-shaped vases, and terminating at the far ends with cornets, or trumpet-shaped beakers, wider at the neck than the foot (a garniture of this type can be seen on a painted fan held at the V&A: T.155–1978). While the forms are basically Chinese, the shapes are similar to Dutch and French tin-glazed earthenware copies introduced in the 1660s.[8]

Between 1600 and 1657, wealthy Europeans had been supplied with ever-increasing quantities of Chinese porcelain, including two important new forms. The first was the jar – a large, handle-less vessel with a cover, practical for storing luxurious food stuffs; the second was the tall cylindrical beaker, as wide at the neck as at the foot, with no obvious function, or its variant: another cylindrical vase, but with a short-waisted neck, known by the Dutch term *rolwagen* (see, for example, pp.24–5). When new, they were frequently acquired in pairs, and arranged symmetrically above

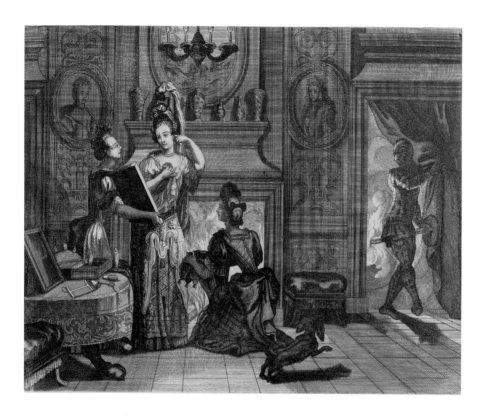

Attributed to Nicolas Bazin (c.1681–1707),
after Jean Dieu de Saint-Jean
Femme de qualité s'habillant pour Coure le Bal
(Gentlewoman dressing for a court ball), 1684–90
Published by Jan van der Bruggen (1648/9–90), Paris
Etching and engraving
35.6 × 39.1 cm
Rijksmuseum, Amsterdam

large cupboards or hooded chimneys, as can be seen in contemporary paintings such as Emanuel de Witte's *Portrait of a Family in an Interior* (1678, Alte Pinakothek, Munich). The quantity of porcelain displayed was evidence of wealth and access to privileged networks of exchange. However, imports virtually ceased during the tumultuous transition from the Ming to the Qing dynasty in China, with the last sizeable shipment occurring in 1647. Official trade between China and the West did not resume until about 1683.

In the interim, and as early as 1660, French merchants commissioned sets – copies of Chinese porcelain – from Dutch potters in Delft. Many were intended for wealthy clients, who wished to emulate the Chinese porcelain displays of the aristocracy. Similar sets were ordered from French potteries, initially at Nevers, in Burgundy, and, later, from Rouen and Saint-Cloud. Agents of the Dutch East India Company evidently also sent elements of Delft garnitures to Japan to be copied in porcelain, as part of their private trade; from 1659 they turned to potters in the town of Arita to supply Europe with Chinese-style porcelains.[9] Japanese potters continued to supply costly, and primarily five-piece, garnitures well into the 1740s.

This demand for garnitures was fuelled by the introduction, in the second half of the seventeenth century, of smaller-scale chimney surrounds, with a prominent new mantelpiece at breast height. The fireplace formed the central focus in intimate, private apartments, and the mantelpiece acted as a fixed stage for a changing tableau of small luxury goods, including garnitures. The mantel was often surmounted by a looking-glass, creating the sense of theatre and illusion that is characteristic of Baroque interiors. Designs for this area of the room, with serial garnitures, perhaps

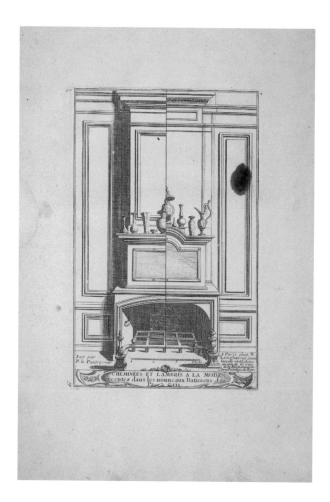

Pierre Lepautre (1652–1716)
Cheminées et lambris à la mode
executez dans les nouveaux bâtimens
de Paris (Fashionable chimneypieces
and paneling executed in the new
buildings of Paris), *c.*1695
Etching
20.5 × 13.3 cm
The Getty Research Institute,
Los Angeles

of Nevers earthenware, were circulated in French engravings that recorded the interiors and taste of Paris's merchant classes and lesser nobility (see opposite). When grouped together, these vessels formed a single, strong visual unit within a richly decorated interior.

In England, during the hiatus in Chinese porcelain imports, the well-to-do had greater access to Japanese porcelain garnitures through private trade, as well as Dutch earthenware. Remarkably, ornamental jars and beakers are virtually unknown in seventeenth-century English delftware (also a tin-glazed earthenware), a reflection of the ware's low status among elite consumers. Instead, garnitures were ordered in silver. In 1673, diarist John Evelyn remarked on the 'silver jarrs and vasas, Cabinets & other so rich furniture, as I had seldom seene the like' in the new dressing room of Elizabeth Bennet, Countess of Arlington, at Goring House, London (later the site of Buckingham Palace).[10] Jars, beakers, double-gourd bottles, flasks and rosewater sprinklers produced in low-gauge silver after Chinese shapes, with rich repoussé and chasing, became the ultimate status symbol in ostentatious display during the Restoration period (see pp.26–31).

When the Chinese porcelain trade resumed in the early 1680s, the first vase sets were probably assembled from the existing stock of Chinese merchants. For example, in the Royal Collection at Kensington Palace, London, there is a rare, five-piece garniture composed of two pairs and a singleton, painted in underglaze blue and polychrome overglaze enamels (see overleaf). It was possible to make up pairs because these jars and beakers were produced in large quantities for China's literati and merchant classes (who displayed them in a secular context as single jars

Five-piece garniture on a lacquer cabinet, Kensington
Palace, London, c.1660–80
Porcelain, underglaze cobalt blue and polychrome enamels
Height: 49.5 cm
Jingdezhen, Jiangxi province, China
Royal Collection Trust

or beakers). Soon, however, Europeans were commissioning jars and beakers with matching decoration in less expensive, blue-painted patterns. Unlike costly Japanese garnitures, where one design was often unique to a five-piece set, the Chinese had streamlined production by mass-producing hundreds of jars and beakers with the same pattern, offering consumers more flexibility in their display. Their archetypal five-piece sets (see pp.36–7) were promoted by merchants as affordable, ready-made, matched versions of the older Chinese porcelain acquired before the export trade officially ceased in 1657. These fashionable instant garnitures, whether of new Chinese porcelain or European earthenware, appealed to the lesser gentry and commercial elite, who aspired to own objects with the 'patina' of ancestry.

In English interiors, where cabinets and chimneys were generally smaller than their Continental counterparts, three-piece sets were much easier to display. A notable exception can be seen in Arthur Devis's portrait of William Atherton, a wealthy Lancashire wool draper, and his wife (c.1743, Walker Art Gallery, Liverpool), which depicts a five-piece, blue-painted set, perhaps Chinese, of around 1700, evenly spaced along the cornice of an English cabinet-on-stand. In fact, the English preference for corner fireplaces with tiered shelves for pyramidal displays, as at Beningbrough Hall, North Yorkshire, made their homes best suited for massed displays of smaller-scale porcelain (Marot referred to this type of chimneypiece as a '*cheminée à l'angloise*'.) Indeed, more typical of English taste were large assembled sets of mixed pairs, at their most extreme resembling the crowded arrangement in William Hogarth's *The Tête à Tête* from the satirical group *Marriage A-la-Mode* (c.1743, The National Gallery, London).

Such dense arrangements are hinted at in an anonymous poem, 'The Woman of Taste', from 1733 – in rebuke of excess: 'Spare no expense to make your *Villa* fine … *China* her jars, and costly vases shew, Load the gilt chimney and japan'd bureau.'[11] In 1748, Frances Evelyn Boscawen, who corresponded weekly about furnishing her London home with her seafaring husband Admiral Edward Boscawen, wrote 'I have tried at china ornaments for my chimney-pieces, which demand them in great quantities, but I have not been able yet to raise myself to the price of anything good and I don't care for a parcel of trumpery – like some chimney-pieces we know of.'[12] Her letter reveals the importance of acquiring the appropriate ornaments to reflect a family's stature.

Garnitures were part of the stock repertoire of European and English ceramic factories from their inception. At Meissen – the first European manufactory to produce true porcelain in the Chinese manner, in 1710 – the grandest were usually seven-piece sets for the mantelpiece. These were assembled from stock – sometimes mixing pairs in different ground colours, sometimes personalized with armorials – and often given as diplomatic gifts. Well into the 1750s, their shapes typically imitated Chinese jars and beakers. An early departure from the Chinese prototype was a seven-piece garniture, designed by Raymond Leplat in around 1715 after European baroque metalware, which was too costly to repeat.[13]

Evidence that more modest Meissen garnitures were present in England by 1755 is provided by a set of jars and a beaker made at the Chelsea porcelain manufactory and now held at Stourhead, in Wiltshire (pp.48–9). Large garnitures were listed in the London factory's 1755 auction catalogue: 'A set for a chimney piece or a cabinet,

consisting of 7 Jars and Beakers, beautifully enamelled with flowers, and the beakers filled with flowers after nature.'[14] The design of the Stourhead set is almost identical to that of the five-piece Meissen sets ordered by the Prussian ruler, Frederick the Great, for his New Palace in Potsdam, where they were originally displayed on individual, gilt wall brackets, and only later arranged as sets on chimney mantels.

The discovery of ancient Greek vases at Herculaneum and Pompeii, in 1738 and 1748, had introduced an entirely new design idiom, which included footed urns and vases with handles. The newly established French porcelain manufactory at Vincennes, which moved to Sèvres in 1756, rejected Chinese forms for innovative shapes drawn from goldsmiths' work, hardstones, antiquity and engraved sources. The ingenious French five- or three-piece garnitures, were typically united by singular, rich ground colours (see pp.56–7). The vases were often intended to display cut flowers and, for a short while, growing bulbs in water – a fashion begun in 1749.[15] Sèvres garnitures were frequently displayed on commodes and pier tables, while, in England, there is evidence that some were displayed on dessert tables as part of the surtout or centrepiece.[16]

Since the mid-seventeenth century, metal mounts had been used to unify ceramic vessels as matched sets, but also to integrate them with the style of the day, as is exemplified by a pair of vases from Tatton Park, Cheshire, presumably once part of a larger garniture (see pp.46–7). A leading Parisian merchant had evidently acquired a set of blue-ground vases when new and emphasized their set-ness with costly mounts in ormolu (gilt bronze) in the fashionable Rococo style. At The Vyne, Hampshire, only the centre vase of a celebrated three-piece, ormolu-mounted

garniture survives, purchased in Paris in 1765 by Horace Walpole for his friend John Chute (see p.47).[17] It is also blue-glazed but, rather than Chinese porcelain, it was made at the Sèvres manufactory, in sections, specifically to be mounted in gilt bronze in the short-lived *goût grec* (Greek taste). In 1995, a pair of Sèvres, blue-ground vases with similar mounts was acquired to recreate the lost garniture.

In the hands of Josiah Wedgwood and his partner Thomas Bentley, garnitures took a new direction in the later eighteenth century (see pp.52–5), influenced by the 1766–7 catalogue of the antique Greek vases in Sir William Hamilton's collection. In 1769, the self-proclaimed 'Vase-maker General to the Universe' tapped into the public's insatiable appetite for vases, which he described as a 'violent Vase Madness', by allowing them to create their own garnitures from over 50 shapes in his order books in a variety of materials, including black stoneware, termed 'black basalt'. By 1775 there were 511 shapes to choose from. Customers were encouraged to mix vases with bronze sculpture on the mantelpiece. Other British porcelain manufacturers copied many of Wedgwood's shapes, creating chimney ornaments designed to perfume the air throughout the seasons (see pp.58–9).

Garnitures of the Baroque period, which emphasized a family's cultural capital and ancestry, continued to be collected. A large Japanese beaker, apparently from a seven-piece set of beakers in four sizes, is depicted in a watercolour of around 1780 (see p.43) recording the stock of a Parisian *marchand-mercier* (decorative arts dealer), along with pieces from a grander, but more common, five-piece cupboard garniture, popularly known as a *kaststel* in the Netherlands.[18] The beaker in the watercolour matches that in a five-piece, Japanese, porcelain garniture in three sizes, at Dunham

Massey, Cheshire (see p.42). The seven-piece set suggests that these atypical garnitures formed a triangular display, descending symmetrically from the centre on narrow chimneys (as any variant would sit uncomfortably). In reality, personal taste ultimately dictated how these garnitures were arranged.

By the 1870s, the Aesthetic Movement championed the single 'unique' vase over complete sets of vases in the same mass-produced pattern, and formal sets fell from fashion. After 200 years, few garnitures found in historic houses were in perfect, complete condition. They had begun to be sold and split up. As a consequence, today the story is reversed, and sets are rarer than singletons. Those elements of garnitures with matching patterns have a hope of one day being united, but those without, united only by a complementary colour, missing mounts or the taste of an individual, are probably lost forever.

Patricia F. Ferguson, National Trust Advisor on Ceramics

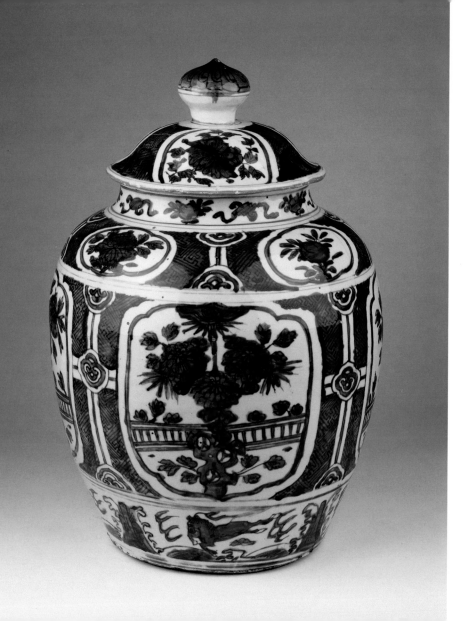

Jar
*c.*1600–20

Chinese porcelain jars were ideal for the safe storage of foods. In China, they were given as presents to mark the New Year, filled with ginger or candied fruit. They arrived in Europe from 1600 until around 1647, through agents of the East India Companies, and were appreciated not only for their practicality, but also for their ornamental qualities. In Dutch, French and English interiors, they were frequently found stored above cupboards (see right) or shelves in the principal living rooms and on mantelpieces. The 1641 inventory of the Pranketing (Banqueting) Room at Tart Hall, near St. James's, London, home of Alethea Howard, Countess of Arundel, records as sitting above the dresser, seven very large jars with covers of porcelain and 'in the corners of the Chimney two Jarres'. [19]

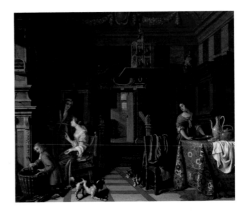

Porcelain, underglaze cobalt blue (unmarked)
Height: 44 cm
Jingdezhen, Jiangxi province, China
V&A: 1720&A-1876

Cornelis de Man (1621–1706)
The Interior of an Elegant Townhouse, with a Lady and Gentleman beside a Fire, a Servant Stacking Logs and a Maid beside a Table, c.1670–5
Oil on canvas
66.5 × 80.5 cm
Private collection

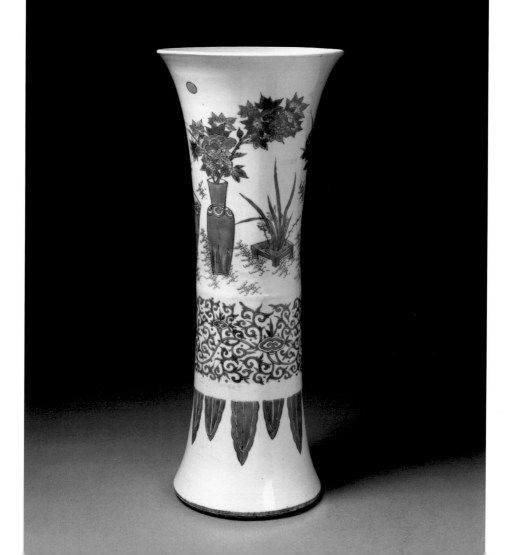

Beaker
*c.*1630–45

In China, porcelain beakers painted with narratives or auspicious motifs first appeared in the 1630s. Scholars, and the merchants emulating them, displayed flowers, peacock feathers or coral branches in the slightly flaring vessels, which were based on archaic bronze shapes known as *gu*. They sat on desks or low tables in studies, as singletons, along with other venerated objects, as can be seen in the mid-seventeenth-century woodblock print shown right. On the table, a slender beaker holds a single, flowering camellia branch. According to Zhang Chou's *Ping Hua Pu* (A Treatise on Flowers suitable for Vases, 1595), porcelain vases were appropriate for the summer and autumn. When they arrived in Europe, in around 1640, the skilfully painted beakers had little obvious function. They were acquired as pairs when new, for symmetrical display, placed at the corners of chimneys or cupboards, often joined by other pairs of vases.

Porcelain, underglaze cobalt blue (unmarked)
Height: 48 cm
Jingdezhen, Jiangxi province, China
V&A: CIRC.419–1931

A beaker vase with a camellia branch on a scholar's table,
mid-17th century
Woodblock print
29 × 29.5 cm
British Museum, London

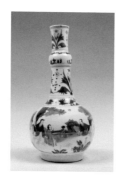
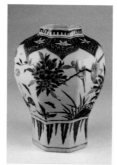
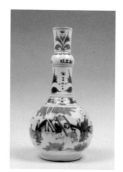
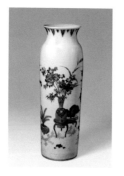
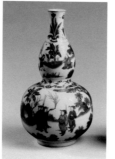
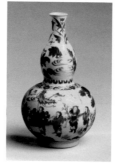
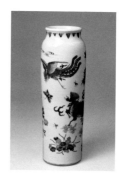

Seven-piece garniture, assembled from blue-painted porcelain, *c*.1640

This seven-piece garniture has been assembled from various sources specially for this publication. It is based on the shapes depicted in French fashion engravings from the 1680s (see right). At the ends would stand two cylindrical *rolwagens* and, in the centre, a jar. In-between would be two pairs, in this case long-necked flasks (a Middle-Eastern form) and double-gourd-shaped bottles (a Taoist symbol of immortality). Remarkably, both of these pairs, from two different National Trust properties, have probably been together since the 1640s. A similar grouping, of four pairs of Chinese porcelain vases, has been in the *Kunstkammer* at Rosenborg Castle, Copenhagen, since before 1737. Similar garnitures may have ornamented a mantelpiece or the flat surface on top of large French cabinets of the 1650s, these also being acquired in pairs, as in the private apartments at Knole, Kent (see overleaf).

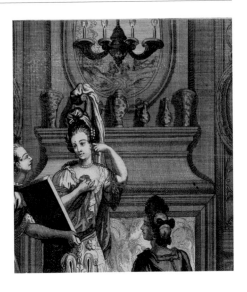

Attributed to Nicolas Bazin (c.1681–1707),
after Jean Dieu de Saint-Jean
Femme de qualité s'habillant pour Coure le Bal
(Gentlewoman dressing for a court ball, detail), 1684–90
Published by Jan van der Bruggen (1648/9–90), Paris
Etching and engraving
35.6 × 39.1 cm
Rijksmuseum, Amsterdam

Porcelain, underglaze cobalt blue (unmarked)
Height: 46 cm
Jingdezhen, Jiangxi province, China
V&A: C.159–1938, circ.410–1931, C.419–1926; National Trust, Ickworth, Suffolk: 848744.1-2; National Trust, Scotney Castle, Kent: 790318.1-2

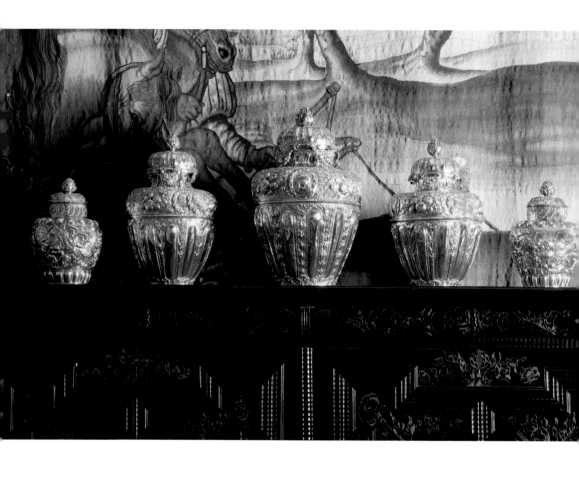

Five-piece cabinet garniture, *c.*1670–80

In England, during the Restoration, when fresh supplies of Chinese porcelain were no longer available, fashionable members of the aristocracy and court commissioned sets of silver vessels, imitating porcelain forms. There was no prescribed formula to these sets, which included beakers, bottles, sprinklers and jars. This unmarked set comprises five, graduated, covered jars, after Chinese porcelain originals, and no beakers. The 'wrought' (repoussé and chased) decoration is of classical European design rather than chinoiserie. It was originally displayed on one of two mid-seventeenth-century, French, ebony-veneered cabinets-on-stands. There were several silver garnitures at Knole, Kent, acquired by the Earls (later, Dukes) of Dorset. In 1780, on a visit to Knole, Horace Walpole remarked, 'Wrought silver, very old & many Jars & beakers of the same'.[20]

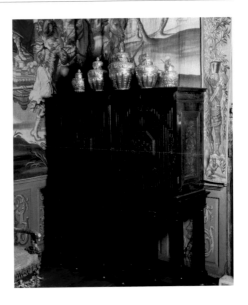

Silver (unmarked)
Height: 43.2 cm
London, England
Private collection, on loan to Knole, Kent

Displayed on a cabinet-on-stand (c.1650), in the Kings Room at Knole, Kent

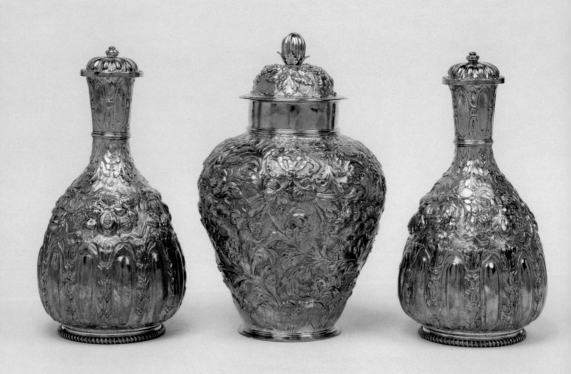

Three-piece cabinet garniture, 1675–6

The workmanship in thinly gauged silver vessels such as these was evidently appreciated long after the fashion for them had disappeared, as they were often preserved by succeeding generations. On 18 April 1747, the *Daily Advertiser* announced an auction of silver and plate possibly belonging to the late George Villiers, 2nd Duke of Buckingham, which included jars and beakers – 'ornamental pieces for Cabinet'. The Earls of Ashburnham acquired this three-piece set, second-hand, and it was later gilded and engraved with the Earl's coronet and cipher. Already by 1817, according to the inventory of plate, it was no longer for display as a cabinet garniture, rather it was part of the 'Sideboard Plate', listed as '2 embossed Bottles … 1 embossed d[itt]o. Jar'.[21] The original owner is unknown.

Silver, later gilded
Marks: 'WW' with a fleur-de-lis and two pellets (jar);
'AM' in monogram crowned (flasks)
Height: 37 cm
London, England
V&A: M.46–1914. Gift of Harvey Hadden.

Beaker and bowl, from a five-piece cabinet garniture, *c.*1677

This beaker and bowl form part of a silver garniture at Knole, Kent, recorded in a 1690 inventory of plate as '1 Chast [chased] Jarr & Cover, 2 Chast Beakers, 2 Chast flower basons'.[22] The central jar of the garniture, which has lost its cover, has a different chased decoration to the rest of the set (see right). The set bears the arms of either Richard Sackville, 5th Earl of Dorset, or his son Charles Sackville, 6th Earl, who inherited the estate in 1677. The shapes are direct copies of Chinese porcelain, but with European decoration. Similar groupings of five Chinese-style, blue-painted objects appear above large cupboards in seventeenth-century paintings of Dutch interiors. Bowls from a five-piece garniture are placed at the corners of a large cupboard (*kast*) in Cornelis de Man's *Family Group in an Interior* (*c.*1658–60, J. Paul Getty Museum, Los Angeles).

Charles Essenhigh Corke (1852–1922)
A silver garniture in the Colonnade Room at Knole, Kent,
*c.*1889
Photograph
14 × 8 cm
National Trust

Silver (unmarked)
Inscription: base engraved with arms of the Earls of Dorset
Height: 38.1 cm
London, England
Private collection, on loan to Knole, Kent

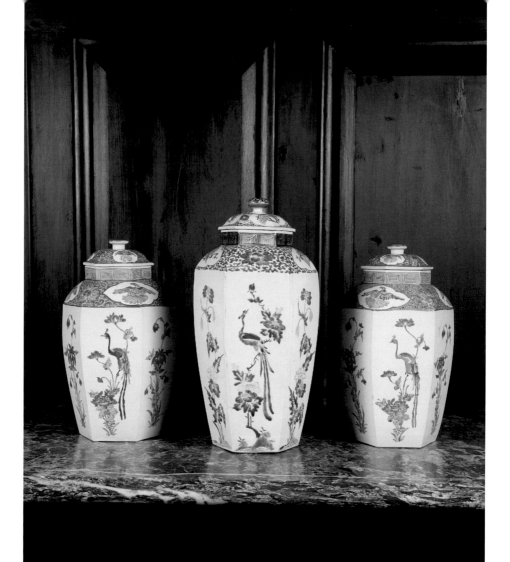

Three-piece garniture in the Kakiemon style, *c.*1680

Between 1659 and 1740, agents of the Dutch East India Company ordered Chinese-style porcelain from Japanese potters. *Rolwagen* vessels were commissioned as early as 1661 and were followed, later, by jars and beakers. In 1677, 36 'pots for display on cabinets, all with blue painting', and others in half-blue and half-red were delivered to Dutch warehouses in Batavia (now Jakarta, Indonesia).[23]

A three-piece, mixed garniture survives at Dunham Massey, Cheshire; the tall hexagonal jar, the rarest of the three, may match those delivered in 1677. The smaller jars are known as 'Hampton Court' jars, as 'one coloured jar and cover of six squares' was recorded in the collection of Mary II at Kensington Palace, London, around 1695, and three survive in the Royal Collection.[24] These jars, for which no matching beaker is known (see, in contrast, the set shown right), were still in demand in the mid-eighteenth century, when they were copied at factories in Meissen and Chelsea.

Porcelain, polychrome enamels and gilding (unmarked)
Height: 38.1 cm
Arita, Hizen province, Japan
National Trust, Dunham Massey, Cheshire: 929282.1-2, 929283.1-2

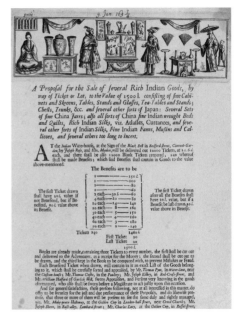

A broadside announcing a lottery of rich Indian goods by John Rose and Elizabeth Madox, Covent Garden (detail), 1694
Engraving
36 × 22 cm
Houghton Library, Harvard University, Cambridge, Massachusetts

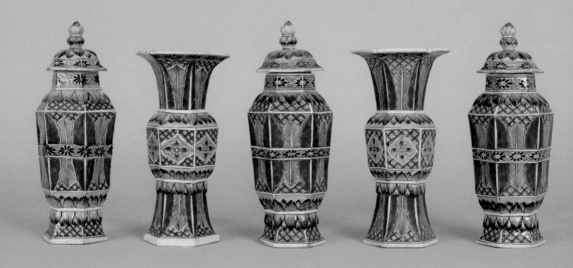

Five-piece *yingcai* (or *famille verte*) garniture for an overdoor, *c.*1685-95

French prints of this period (see right) promoted the practice of displaying garnitures on cornices over doors (overdoors); matching garnitures would be placed over the chimney in the same interior. The fashion emphasized the importance of repetition in Baroque interiors, used to create a sense of order. Several dozen vases were required to furnish a room, with seven or nine pieces on a chimney and a matching set of seven or nine pieces on the cornices. A room furnished with dozens of pieces in the rare pattern shown on this five-piece set of jars and beakers would have been spectacular. Their strong palette is in the so-called *famille verte* (green family; Chinese: *yingcai* or *wucai*), but painted onto a thinly glazed surface to result in a greyish appearance. The connoisseur Mrs Hannah Gubbay acquired the set in the twentieth century.

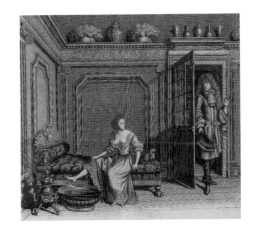

Porcelain, polychrome enamel over a thin glaze
Height: 26.9 cm
Jingdezhen, Jiangxi province, China
National Trust, Clandon Park, Surrey: 1440409.1-5

Attributed to Nicolas Bazin (*c.*1681–1707)
Femme de qualité déshabillée pour le bain
(Gentlewoman undressing for a bath), *c.*1685
Etching and engraving
41 × 38.5 cm
Princeton University Library

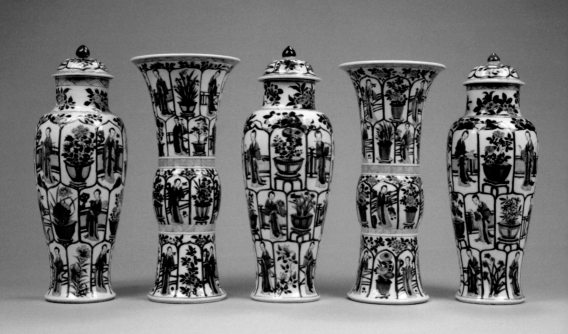

Five-piece *garniture de cheminée*, c.1690–5

At their most basic, Chinese *garnitures de cheminée* such as this, made from the mid-1680s onwards, were composed of two forms – covered jars and beakers. Made to European specifications, they were often slimmer versions of the shapes that were first imported from China in the 1640s. Hundreds of beakers and jars were produced in each pattern. A five-piece set in this style had been acquired by 1701 for the *Kunstkammer* at Rosenborg Castle, Copenhagen. In 1703, '137 Jarrs and waggons [*rolwagens*]' were recorded as private trade cargo on an English East Indiaman sailing from Amoy (now Xiamen), presumably painted in one pattern.[25] The French designer Daniel Marot probably had similar jars and beakers in mind when he designed his elaborate, massed displays for mantelpieces, incorporating mirrors, gilt brackets and shelves, as shown right.

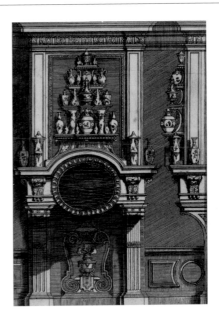

Porcelain, underglaze cobalt blue
Mark: Artemisia leaf
Height: approx. 46.5 cm
Jingdezhen, Jiangxi province, China
V&A: C.842-6–1910. Salting Bequest.

Daniel Marot (1661–1752)
Nouveaux livre de cheminées à la Hollandoise
(New book of Dutch-style Chimneys), 1703
Engraving
24.7 × 16.6 cm
Rijksmuseum, Amsterdam

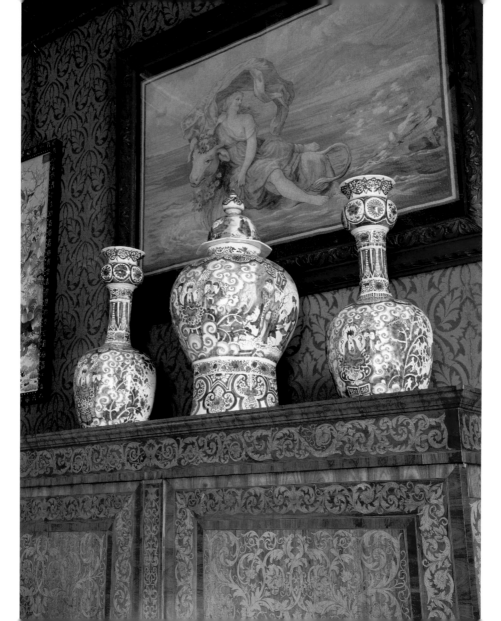

Three-piece cabinet garniture, after Chinese originals, *c.*1695

By the 1660s, Delft potters were able to produce convincing copies of Chinese porcelains of the 1630s and 1640s, both in terms of shape and decoration. French earthenware garnitures made at Nevers are also known, but few complete sets survive from this early period. By the 1690s, three-piece garnitures, such as this example from Kingston Lacy, Dorset, were part of the stock repertoire of most Delft potteries. Elite consumers clearly wanted old-fashioned shapes: octagonal, covered jars and tall flasks with 'knopped' (or knobbed) necks, which had first been produced in Chinese porcelain around 1640. 'Antique' Ming originals would have been rare and probably more expensive. The Kingston Lacy garniture was purchased in 1698. It is recorded in an account book kept by Margaret Bankes: 'Payd for a large delph jar & 2 bottles 3.00.00'.[26]

Tin-glazed earthenware, in-glaze cobalt blue (unmarked)
Height: 72 cm
Delft, the Netherlands
National Trust, Kingston Lacy, Dorset: 1250639.1-3

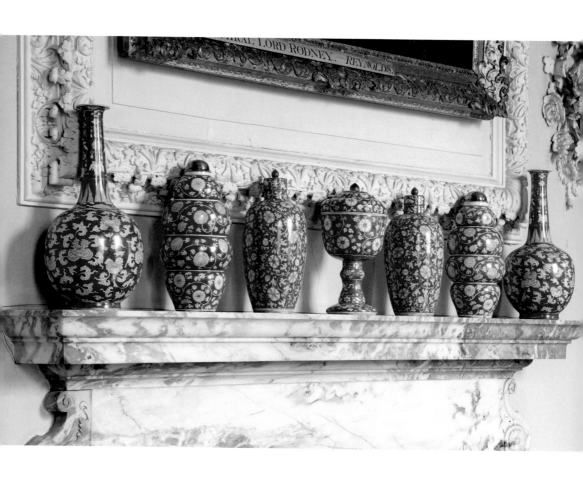

Seven-piece garniture of 'red-and-white' design, *c*.1695–1715

In the private apartments of Petworth House, West Sussex, there is a remarkable collection of Chinese porcelain painted in iron-red enamels. Both the palette and shapes, such as the quadruple-gourd jars, are rare and novel. In an inventory of Petworth prepared in 1748, following the death of Charles Seymour, 6th Duke of Somerset, the garniture is recorded in the South Gallery on the 'Bedchamber Floor' as '9 ornamental pieces of red and white china over the chimney and 14 d[itt]o. over the two doors'.[27] 'The Proud Duke', as he was known, had inherited Petworth through his wife, the wealthy heiress Lady Elizabeth Percy. In the 1690s, the French designer Daniel Marot was involved in its rebuilding.

Porcelain, iron-red enamel; silver (unmarked)
Height: 36 cm
Jingdezhen, Jiangxi province, China
Collection Lord Egremont at Petworth House, West Sussex

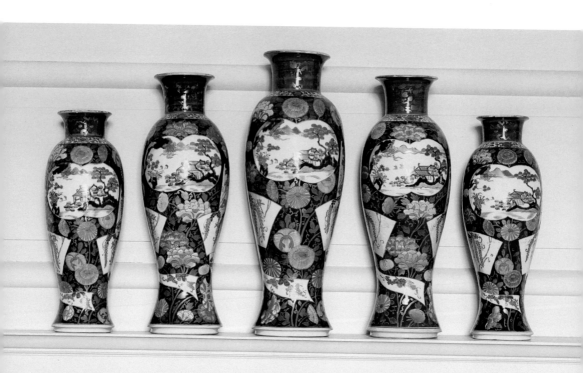

Five-piece garniture of beaker-vases, in the Imari style, c.1700–20

At Dunham Massey, there are two sets of Japanese beaker-vases: this five-piece and an incomplete set of four. Their elegant shapes are indirectly based on Chinese *rolwagens* and their narrow dimensions allow great flexibility of display. A similar, single beaker-vase, from a seven-piece set in four sizes, is recorded in a watercolour of around 1780 (see right). The work illustrates a French merchant's stock and was commissioned to solicit orders – it is evidence that Japanese garnitures such as these were still in demand decades after their creation. Beaker-vases were popular in England – often found in pairs – but sets are rare. The Dunham sets may have been acquired by George Booth, 2nd Earl of Warrington and owner of Dunham Massey, who married the daughter of a successful London East India Company merchant in 1702.

Porcelain, underglaze cobalt blue, polychrome enamels and gilding (unmarked)
Height: 51 cm
Arita, Hizen province, Japan
National Trust, Dunham Massey, Cheshire: 929278, 929298.1-2, 929331.1-2

Three Japanese vases, c.1780
Watercolour and ink
37.8 × 23.3 cm
The Metropolitan Museum of Art, New York

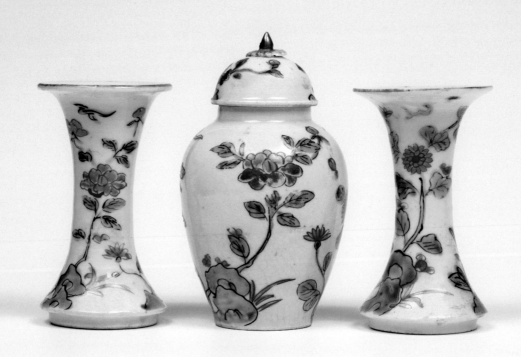

Three-piece garniture from a 'baby house', c.1700–20

In the drawing room of the 'baby house' (an eighteenth-century term for a dolls' house) at Nostell Priory, Yorkshire, a house built around 1735 for Lady Susannah Winn, there is this small-scale, three-piece, porcelain garniture. The furnishings in these miniature mansion houses, which had a pedagogical function, accurately reflect those found in real homes of the period. Three-piece sets were common in historic English collections and were displayed on the hearth in the summer or above small cabinets. As was typical in Dutch interiors, garnitures were also displayed above large cupboards. A seven-piece set of Japanese jars and beakers is displayed above a cabinet-on-stand in the Dutch dolls' house of Petronella Dunois, built around 1676, which is held at the Rijksmuseum, Amsterdam. The Nostell Priory garniture may have been among the 5,334 sets of dolls' articles exported from Japan as private trade in 1709.

Porcelain, polychrome enamels and gilding
Height: 5 cm
Arita, Hizen province, Japan
National Trust, Nostell Priory, Yorkshire: 959710.2

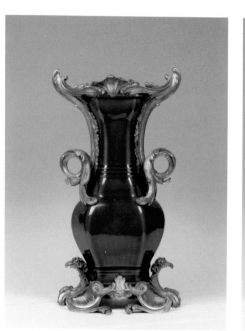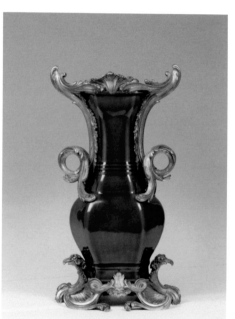

Pair of vases, unified with French ormolu mounts to form a garniture, *c*.1755

Since the mid-seventeenth century, decorative metal mounts have been applied to vases to unify and emphasize their grouping, or to coordinate mismatched objects with other elements in an interior. Initially, precious silver or *vermeil* (gilded silver) was used. Around 1700, the preference was for mounts in gilt bronze, known as ormolu, after the French *bronze doré d'or moulu* (bronze gilded with powdered gold). Mounts were routinely updated as fashions changed. Among the finest from the mid-eighteenth century are those seen on this pair of Chinese vases, probably once part of a larger set. The design of the mounts is often attributed to the court goldsmith Jean-Claude Chambellan Duplessis, and they were cast from an exclusive model commissioned and owned by a Parisian merchant. In the eighteenth century, neoclassical mounts were commissioned by the Parisian merchant Jean Dulac to unify garnitures of Sèvres porcelain (see right).

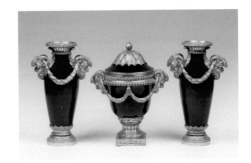

Porcelain, blue-tinted glaze; gilt bronze (ormolu)
Height: 51 cm
Jingdezhen, Jiangxi province, China; Paris, France
National Trust, Tatton Park, Cheshire: 1296815.1-2

Three-piece Sèvres garniture, *c*.1763–5
Soft-paste porcelain; gilt bronze
Height: 28 cm
Paris and Sèvres, France
National Trust, The Vyne, Hampshire

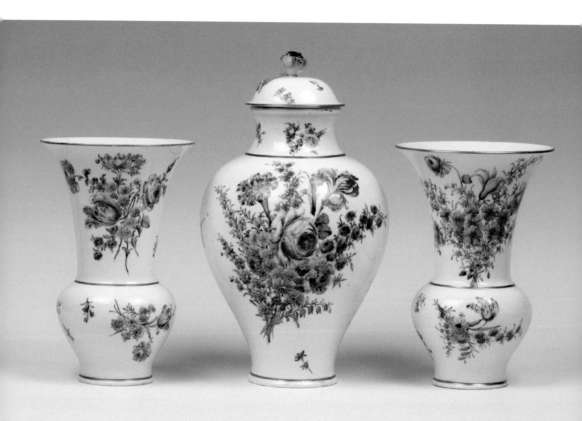

Three-piece, Chelsea-factory *garniture de cheminée*, after Meissen originals, 1755–6

In 1759, the banker Henry Hoare II, of Stourhead, Wiltshire, purchased some 'Chelsea China' from the retailer Joseph Cartony. His purchase may have included this three-piece set. Seven-piece sets of jars and beakers for mantelpieces or cabinets were also made in this period by the factory. Their shapes and floral decoration copy models produced a decade earlier at the royal porcelain factory in Meissen. Frederick the Great of Prussia owned several Meissen five-piece sets and displayed them on gilt brackets in his New Palace in Potsdam. Such shapes may have accommodated the contemporary fashion for growing bulbs in water. A portrait of Princess Christine Charlotte of Hesse-Kassel, painted in 1765 (see right), depicts the practice, with a hyacinth in the uncovered jar at the centre of a garniture.

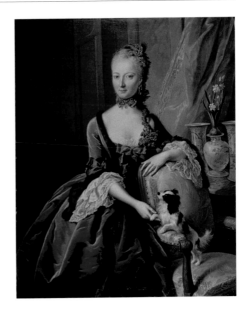

Soft-paste porcelain, polychrome enamels and gilding
Marks: painted with an anchor, in gold, and various numerals
Height: 23.5 cm
London, England
National Trust, Stourhead, Wiltshire: 730534.1-2, 730547.1-2

Johann Heinrich Tischbein the Elder (1722–89)
Princess Christine Charlotte of Hesse-Kassel, 1765
Oil on canvas
147.7 × 112.6 cm
Hessische Hausstiftung, Museum Schloss Fasanerie, Eichenzell

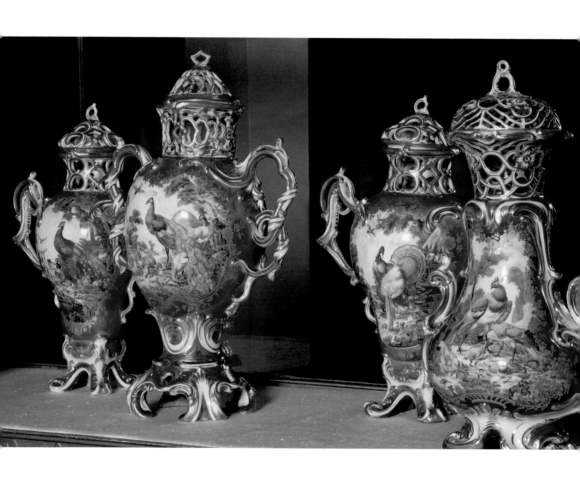

Seven-piece, Chelsea-factory *garniture de cheminée* of 'potpourri vases', *c.*1762–4

The most celebrated English garniture was purchased in the 1920s by Marcus Samuels, founder of Shell Oil and later 1st Viscount Bearsted. Its history can be traced to the 1850s, to Knole, Kent, though we do not know who commissioned the avant-garde, highly erotic, mythological scenes on the vessels, many after French painter François Boucher, paired on the reverse with bucolic peacocks in the manner of Melchior d'Hondecoeter. Their design, a form of extreme Rococo, illustrates the Chelsea factory's adoption of contemporary French taste, the style of the enemy during the Seven Years' War. This exaggerated English style, then known as the 'Anti-gallican spirit', aimed to rival French luxury. The four different jar shapes, designed to contain potpourri, astonish with their virtuosity and variety, surpassing anything created at the Sèvres manufactory. Whether their design is 'beautiful' is hotly contested.

Soft-paste porcelain, polychrome enamels and gilding
Marks: painted with an anchor, in gold, and various numerals
Height: 42.5 cm
London, England
National Trust, Upton House, Warwickshire: 446369.1-14

Detail showing central vase, with erotic scene of 'Alphée et Aréthuse', after Pierre-Charles Trémolières (1703–39)

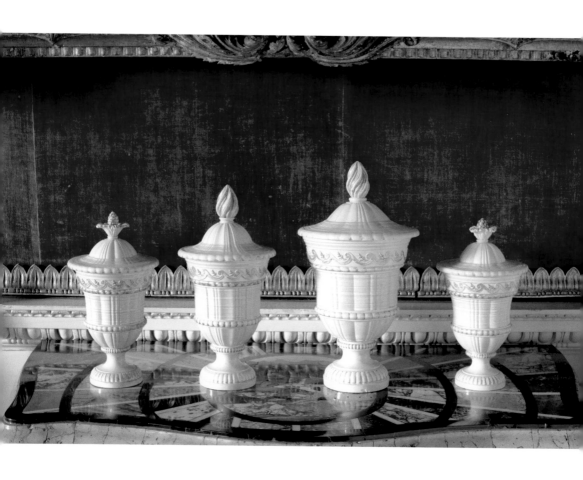

Four covered Wedgwood vases, after turned ivory, *c.*1767–9

Keen to capitalize on the interest in vases inspired by discoveries at Herculaneum and Pompeii, Josiah Wedgwood experimented with his new Queen's ware, briefly known as 'Ivory'. Between 1765 and 1769, the potter invented several shapes after designs by the royal architects William Kent and Sir William Chambers, but also inspired by the princely craft of ivory turning. Since the seventeenth century, the European nobility had employed engine-turned lathes to create elaborate vases with distinctive, eccentric, wavy lines. Wedgwood taught himself to use similar lathes and applied the technique in decoration for ceramics. Wedgwood proposed presenting Charlotte, wife of George III, with two sets of vases, one engine-turned and the other with printed ornament. The four covered vases from Saltram are rare examples of this short-lived enterprise. They may have originally formed a complete, five-piece set or, as is suggested by the mismatching finials, two different sets.

Cream-coloured earthenware (Queen's ware) with unfired gilding (unmarked)
Height: 33.8 cm
Etruria, Staffordshire, England
National Trust, Saltram, Devon: 870784.1-2, 870788.1-2

Three Wedgwood and Bentley vases, after antique Greek vases, *c.*1770–80

The publication of a catalogue of Sir William Hamilton's collection of Greek vases between 1766 and 1767 offered Josiah Wedgwood and his partner Thomas Bentley with a limitless source for vase designs. Wedgwood's black stoneware, known as 'black basalt', was ideal for interpreting the antique, red-figured ware. Hundreds of vase shapes were produced, from which customers could assemble their own garnitures – either plain black or enamel-painted, termed 'encaustic' after an antique process. These three vases from Saltram may have formed an assembled garniture. Wedgwood and Bentley constantly sought new ways to market vases, even introducing basalt figures to be displayed alongside them. Richard Colt Hoare placed an identical pair of open 'Krater' vases in his home at Stourhead, Wiltshire, as is recorded in an 1824 watercolour by John Buckler (British Library, London; see MS 36392).

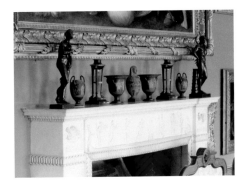

Black basalt with 'encaustic' decoration (unmarked)
Height: 23.5 cm
Etruria, Staffordshire, England
National Trust, Saltram, Devon: 870783 and 870785.1-2

Wedgwood 'krater' vases, mixed with bronze figures, on the mantelpiece of the Picture Gallery, Stourhead, Wiltshire

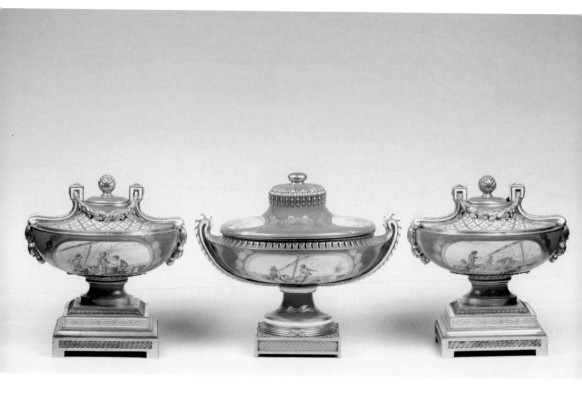

Three-piece, Sèvres-factory *garniture de cheminée*, 1780–1

This Sèvres *garniture de cheminée* at Upton House, Warwickshire, is typical of production at the royal factory from the 1750s onwards. The formula included elegant shapes, here exemplified by two rare, neoclassical models. The shapes are unified by a vibrant *bleu céleste* (heavenly blue) ground colour, accented with rich gold details. Reserved panels were painted with different scenes on each side, with the rear intended to be reflected in a mirror placed over the mantelpiece. Between 1906, when the garniture was owned by the Chérémèteff family, and 1910, when it was sold by the banker Baron Schröder and subsequently acquired by Walter Samuel, later 2nd Viscount Bearsted, mismatched ormolu mounts were added by the dealer Asher Wertheimer. The vases were no longer intended to be displayed as a three-piece garniture.

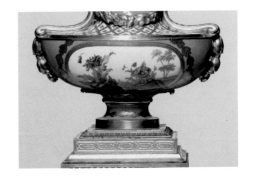

Soft-paste porcelain, with polychrome enamels and gilding; gilt bronze (ormolu)
Mark: painted with date letters and symbols of the painter Jean-Louis Morin (1732–87) and the gilder Henri-Martin Prévost aîné (*fl*.1757–97)
Height: 26 cm
Sèvres, France
National Trust, Upton House, Warwickshire: 446263.1–2, 446264.1–2

Detail of reverse, painted panel with growing plants

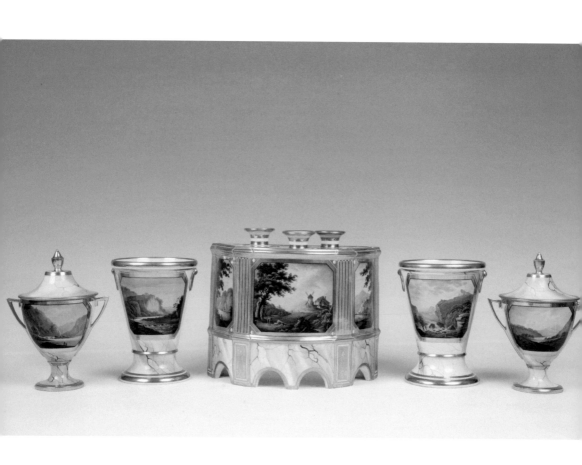

Five-piece, Barr, Flight and Barr-factory *garniture de cheminée*, c.1804–7

Between 1775 and 1825, the English *garniture de cheminée* featured not only vases and jars for cut-flowers, but also pots for growing plants, and bulbous root-pots for forcing hyacinth and other bulbs in water alone. Many of the shapes were inspired by French garnitures in porcelain or *tôle vernis* (painted metal). Vessels were often supplemented with covers, converting them into holders for potpourri or for burning perfumed pellets. Thus, throughout the year, they filled the drawing-room air with varied aromas. Here, the central bulb-pot has a cover with nozzles to support bulbs, their roots fed by the water below. Small holes in the cover held wooden sticks, tied to the hyacinth stems to prevent them from toppling and smashing the pot. Named Irish and Scottish topographical views on the smaller vases cater to the growing popularity of British tourism in search of the Picturesque.

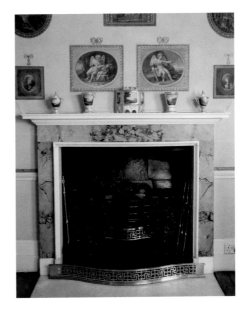

Soft-paste porcelain, painted with enamel colours and gilding
Mark: painted factory mark and named views
Height: 20 cm
Worcester, England
National Trust, Blickling Hall, Norfolk: 353347.1–2, 353348.1–2, 353349.1–4

Displayed in the Print Room at Blickling Hall, Norfolk

Notes

1 Since 1966, it has generally been accepted that European garnitures derived from Chinese, five-piece, porcelain altar sets (*wugong*). Yet these were virtually unknown in the West until Jean-Baptiste du Halde's *Description de la Chine* (1738). The theory is refuted in Yiu 2009, but there may be a link with ecclesiastical altar sets.

2 A portrait of the marquise de Montespan (*c*.1679–85, The Pitti Palace, Florence) by Henri Gascar, depicts two Japanese lacquered cabinets garnished with orderly, blue-painted porcelain garnitures of jars and beakers.

3 *Mercure galant* (December 1682), p.13

4 *Dictionnaire de l'Académie française* (Paris 1694), p.514

5 Fuhring et al. 2015, cat.93

6 Leprince 2014, pp.33–9

7 Murdoch 2006, p.125. See also Arthur Devis, *Portrait of Lady Juliana Penn* (1752, Philadephia Museum of Art).

8 Leprince 2014, pp.110, 246–9

9 Ayers, Impey and Mallet 1990, cats 37, 38

10 De Beer 2000, vol.IV, p.8

11 Aynsley and Grant (eds) 2006, p.121

12 In 1750, the Boscawens acquired Hatchlands Park, Surrey. Aspinall-Oglander (ed.) 1940, p.66.

13 Cassidy-Geiger (ed.) 2007, pp.15, 208

14 Austin 1977, p.41

15 Ferguson 1997

16 Savill 1988, pp.23–9; Savill 2015, p.139

17 Ferguson 2016, pp.116–17

18 The merchant may have been Dominique Daguerre, who was furnishing the palace of Laeken, outside Brussels, for the Duke and Duchess of Teschen. See Dauterman and Parker 1960, p.281.

19 Claxton 2010, appendix, p.7

20 Toynbee 1927–8, p.77

21 Ashburnham MS, ASH/2763

22 Sackville MS, U26/069/1, 1690

23 Viallé 2000, pp.180, 204

24 Hinton and Impey 1998, p.90

25 Godden 1979, p.67

26 Bankes Papers, D/BKL 8C/55

27 Petworth House Archives, PHA 6262

Bibliography

Ashburnham MS, East Sussex Records Office, Brighton, ASH/2763

Cecil Faber Aspinall-Oglander [ed.], *Admiral's Wife: Being the Life and Letters of the Hon. Mrs. Edward Boscawen from 1719–1761* [London 1940]

John C. Austin, *Chelsea Porcelain at Williamsburg* [Williamsburg, VA, 1977]

John Ayers, Oliver Impey and J.V.G. Mallet, *Porcelain for Palaces: The Fashion for Japan in Europe, 1650–1750* [British Museum, London, exhib. cat., 1990]

Jeremy Aynsley and Charlotte Grant [eds], *Imagined Interiors: Representing the Domestic Interior since the Renaissance* [London and New York 2006]

Bankes Papers, Dorset History Centre, Dorchester, D/BKL 8C/55

Maureen Cassidy-Geiger [ed.], *Fragile Diplomacy: Meissen Porcelain for European Courts, ca. 1710-63* [The Bard Graduate Center for Studies in the Decorative Arts, Design, and Culture, New York, exhib. cat., 2007]

Juliet Claxton, 'The Countess of Arundel's Dutch Pranketing Room: "An inventory of all the Parcells or Purselin, glasses and other Goods now remaynîng in the Pranketing Roome at Tart Hall, 8th Sept 1641"', *Journal of the History of Collections*, Past & Present Special Supplement: Relics and Remains [November 2010], vol.22, no.2, pp.187–96

Bente Dam-Mikkelsen and Torben Lundbaek, *Etnografiske genstande i Det kongelige danske Kunstkammer 1650–1800/ Ethnographic Objects in the Royal Danish Kunstkammer 1650–1800* [Copenhagen 1980]

Carl Christian Dauterman and James Parker, '"The Porcelain Furniture" [The Kress Galleries of French Decorative Arts]', *Metropolitan Museum of Art Bulletin New Series* [May 1960], vol.18, no.9, pp.274–84

Esmond Samuel De Beer [ed.], *The Diary of John Evelyn: Now Printed in Full from the Manuscripts Belonging to Mr. John Evelyn* [Oxford 2000]

Anthony du Boulay, 'A Japanese garniture for Nostell Priory', *Apollo* [April 1999], pp.20–3

Patricia F. Ferguson, 'The Eighteenth-century Mania for Hyacinths', *Magazine Antiques* [July 1997], vol.CLI, no.6, pp.844–51
 – *Ceramics: 400 Years of British Collecting in 100 Masterpieces* [London 2016]

Peter Fuhring et al. [eds], *A Kingdom of Images: French Prints in the Age of Louis XIV 1660–1715* [The Getty Research Institution, Los Angeles, exhib. cat., 2015]

Geoffrey A. Godden, *Oriental Export Market Porcelain and its Influence on European Wares* [London 1979]

Gilles Grandjean, *Peinture et sculpture de faïence: Rouen XVIIIème siècle* [Paris 1999]

Mimi Hellmann, 'The Joy of Sets: The Uses of Seriality in the French Interior', in Dena Goodman and Kathryn Norberg (eds), *Furnishing the Eighteenth Century: What Furniture Can Tell Us about the European and American Past* (New York and London 2006), pp.129–53

Mark Hinton and Oliver Impey, *Kensington Palace and the Porcelain of Queen Mary II* (London 1998)

Christian J. A. Jörg, *Porcelain from the Vung Tau Wreck: The Hallstrom Excavation* (Singapore 2001), pp.40–3

Camille Leprince, *Le faïence baroque française et les jardins de Le Nôtre* (Paris 2014)

Hui Lin Li, *Chinese Flower Arrangement* (Philadelphia 1956)

Tessa Murdoch (ed.), *Noble Households: Eighteenth-Century Inventories of Great English Houses, A Tribute to John Cornforth* (Cambridge 2006)

Petworth House Archives, West Sussex Records Office, Chichester, PHA 6262

Sackville Manuscripts, Kent History and Library Centre (KHLC), Maidstone, U269 0.69/1

Rosalind Savill, *The Wallace Collection: Catalogue of Sèvres Porcelain* (London 1988)
 – 'The sixth Earl of Coventry's purchases of Sèvres Porcelain in Paris and London in the 1760s', *French Porcelain Society Journal* (2015), vol.V, pp.133–60

Colin Sheaf, *The Hatcher Porcelain Cargoes: The Complete Record* (Oxford 1988)

Anna Somers Cocks, 'The Nonfunctional Use of Ceramics in the English Country House During the Eighteenth Century', in Gervase Jackson-Stops et al. (eds), *The Fashioning and Functioning of the British Country House, Studies in the History of Art* (1989), vol.25, pp.195–215

Peter Thornton, *Seventeenth-Century Interior Decoration in England, France and Holland* (New Haven and London 1978)

Paget Toynbee, 'Horace Walpole's Journals of Visits to Country Seats, &c.', *Walpole Society* 16 (1927–8), p.77

Cynthia Viallé, 'Japanese Porcelain for the Netherlands: the Records of the Dutch East India Company', in Tomoko Fujiwara (ed.), *The Voyage of Old-Imari Porcelains / Koimari no michi* (Kyushu Ceramic Museum, Arita, exhib. cat., 2000), pp.166–83

Sir Francis Watson and John Whitehead, 'An inventory dated 1689 of the Chinese porcelain in the collection of the Grand Dauphin, son of Louis XIV, at Versailles', *Journal of the History of Collections* (1991), vol.3, no.1, pp.13–52

Josh Yiu, 'On the Origin of the *Garniture de Cheminée*', *American Ceramic Circle Journal* (2009), vol.XV, pp.11–23

Credits

First published by V&A Publishing, 2016
Victoria and Albert Museum
South Kensington
London SW7 2RL
www.vandapublishing.com

Distributed in North America by Abrams, an imprint of
ABRAMS

ISBN 978 1 85177 900 0

10 9 8 7 6 5 4 3 2 1
2020 2019 2018 2017 2016

A catalogue record for this book is available from the British
Library.

For garnitures, the height given is that of the tallest vessel
in the set.

Every effort has been made to seek permission to reproduce
those images whose copyright does not reside with the
V&A, and we are grateful to the individuals and institutions
who have assisted in this task. Any omissions are entirely
unintentional, and the details should be addressed to V&A
Publishing.

Cover: **From a pair of vases, unifed with French ormolu
mounts to form a garniture**, *c.*1755 (see pp.46–7)

Back cover: From a seven-piece, Chelsea-factory *garniture
de cheminée* of 'potpourri vases', *c.*1762–4 (see pp.50–1)

Frontispiece: **Daniel Marot (1661–1752),** *Nouvelles Cheminée
faitte en plusier en droits de la Hollande et autres Prouinces*
(New chimneypieces made for several locations in the
Netherlands and other Provinces), 1703, etching and
engraving, 24.1 × 19.4 cm, V&A: 13857:4

Designer: Joe Ewart, Society
Project editor: Faye Robson
New V&A photography by Richard Davis,
V&A Photographic Studio

Originated by DL Imaging Ltd, London
Printed in China by C&C Offset Printing Co., Ltd.

Exhibition organized
in collaboration with:

Publication and
exhibition supported by:

**National
Trust**

THE
HEADLEY
TRUST

V&A Publishing

Supporting the world's leading
museum of art and design,
the Victoria and Albert
Museum, London